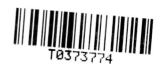

T0373774

THE
HARRY CLARKE
Colouring Book

First published 2015
Reprinted 2020, 2025

The History Press
97 St George's Place, Cheltenham,
Gloucestershire GL50 3QB
www.thehistorypress.co.uk

British Library Cataloguing in Publication Data.
A catalogue record for this book is available from the British Library.

ISBN 978 1 84588 903 6

Typesetting and origination by The History Press
Printed in Turkey by Imak

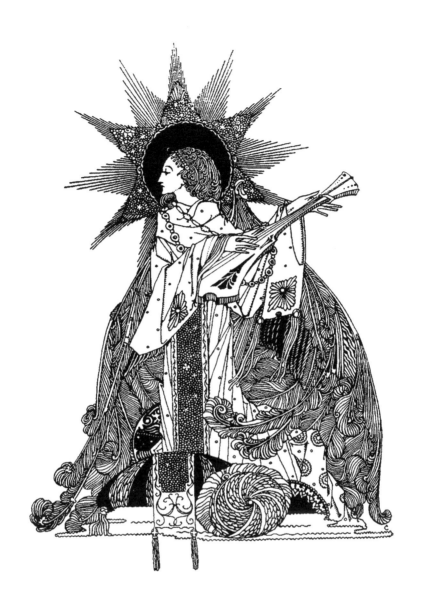

THE
HARRY CLARKE
COLOURING BOOK

St Declan, The Honan Chapel of St Finbarr,
University College Cork, Cork City. ▸

Based on a photograph by Michael Cullen, originally published
in *Strangest Genius: The Stained Glass of Harry Clarke*, by Lucy
Costigan and Michael Cullen, The History Press, 2010.

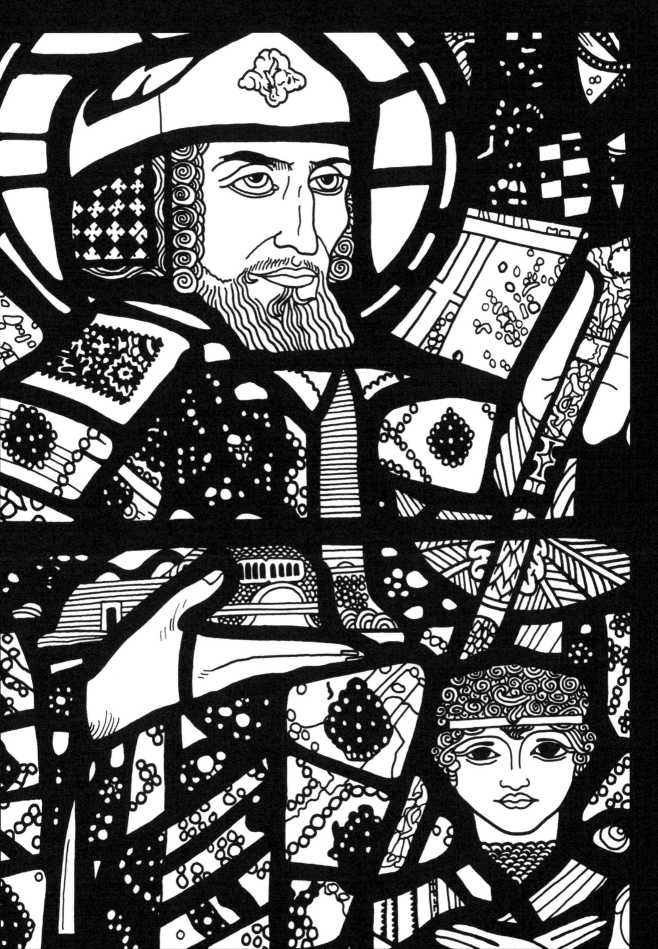

The Resurrection, top of the first light showing
Jesus commanding a crippled man to walk.
Eneriley and Kilbride Church of Ireland
church, near Arklow, County Wicklow. ▶

Based on a photograph by Michael Cullen, originally published
in *Strangest Genius: The Stained Glass of Harry Clarke*, by Lucy
Costigan and Michael Cullen, The History Press, 2010.

Angel playing a musical instrument, half-title
illustration for *The Year's at the Spring* (London 1920). ▶

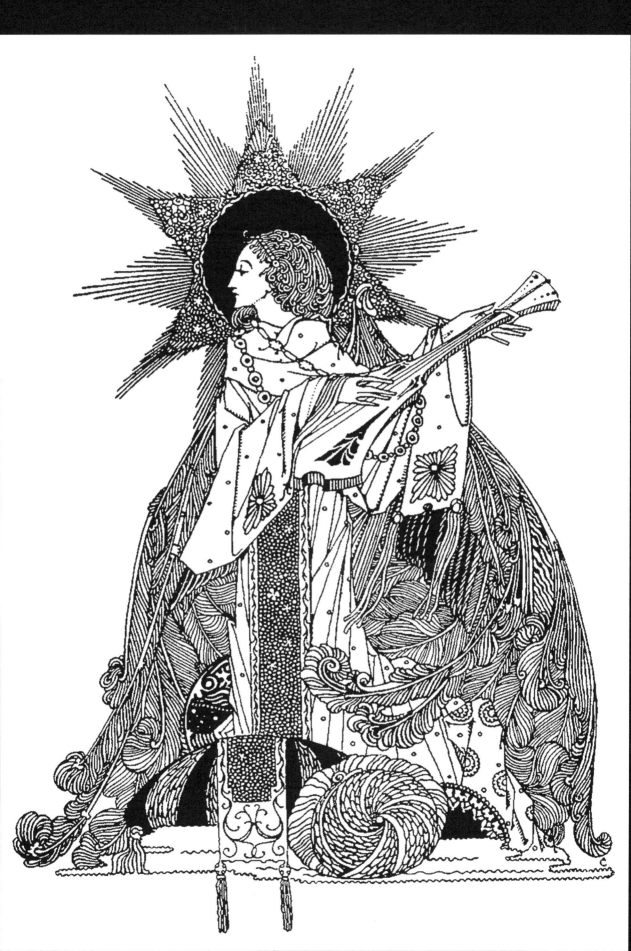

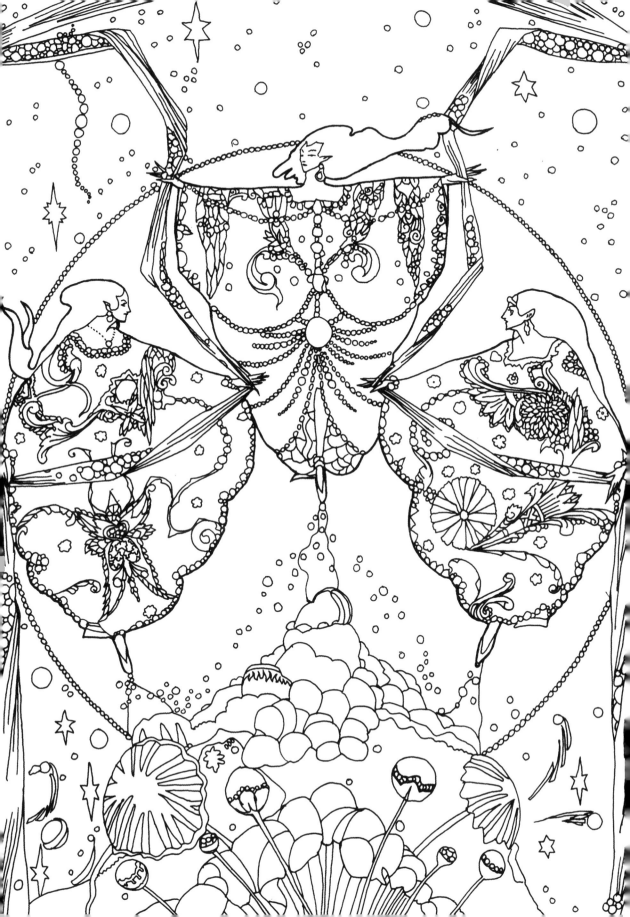

Design from one of the first series of handkerchiefs
Clarke designed for Sefton Fabrics, 1919. ▸

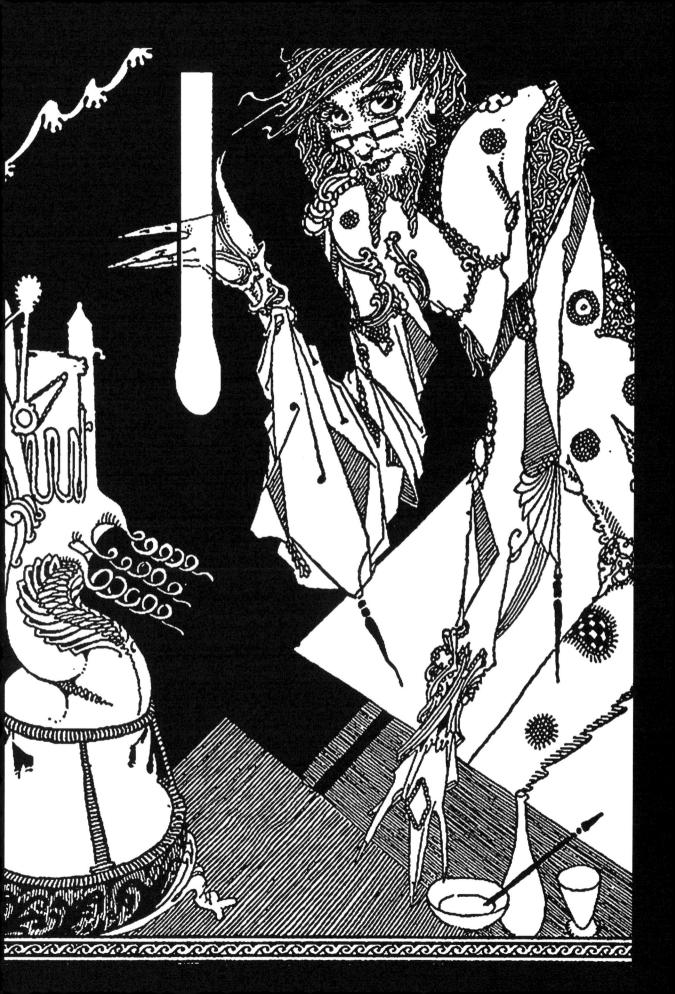

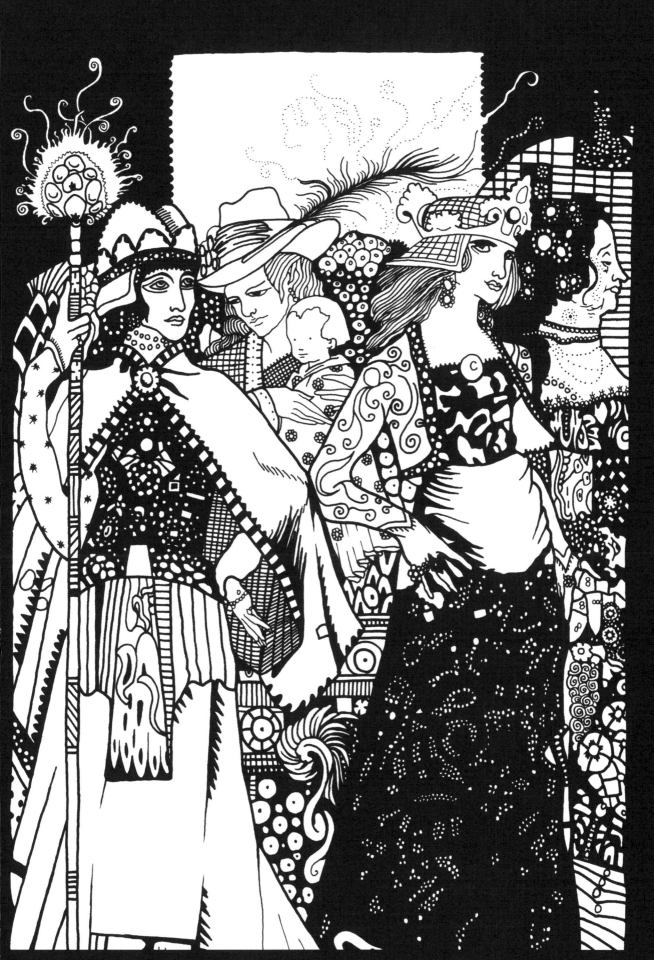

Epilogue panel, concluding illustration
to J.M. Synge's poem, *Queens*, 1917. ▸

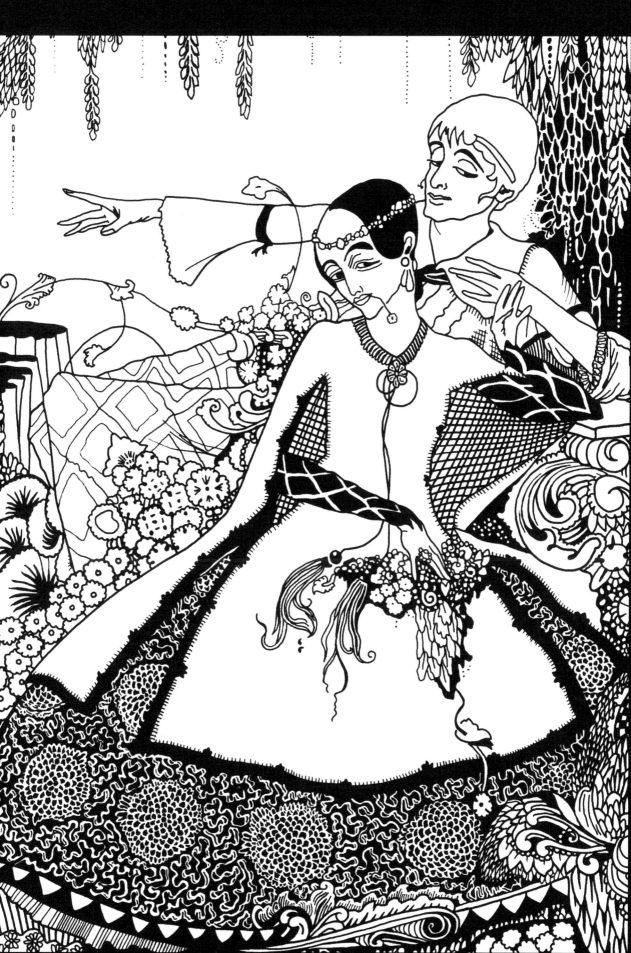

'Bert, the big-foot, sung by Villon, Cassandra,
Ronsard found in Lyon', illustration to
J.M. Synge's poem, *Queens,* 1917. ▸

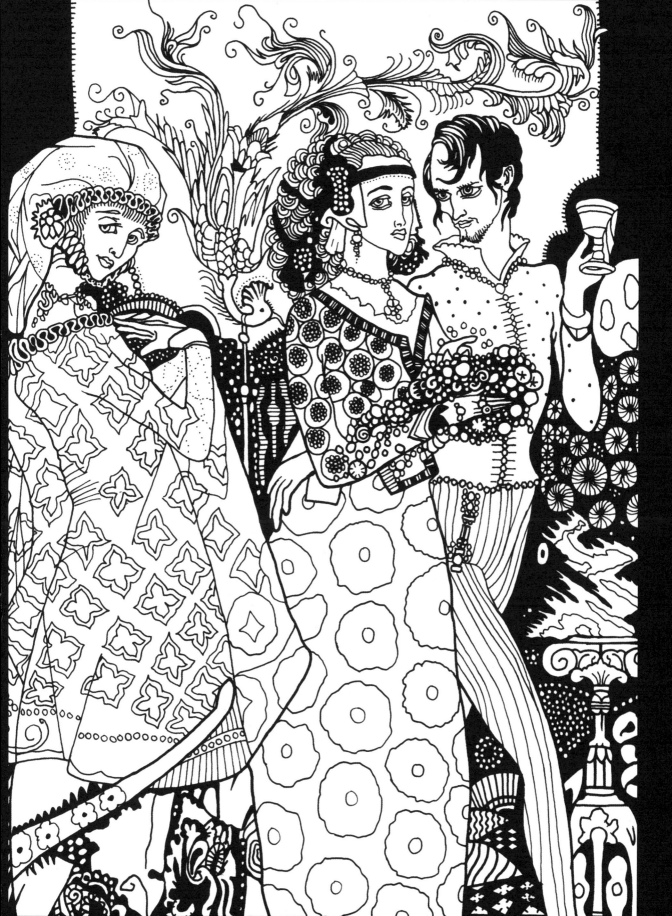

The Coronation of the Virgin in Glory, Coronation light showing detail of Mary with women from the Old Testament. St Joseph's Catholic church, Terenure. ▸

Based on a photograph by Michael Cullen, originally published in *Strangest Genius: The Stained Glass of Harry Clarke*, by Lucy Costigan and Michael Cullen, The History Press, 2010.

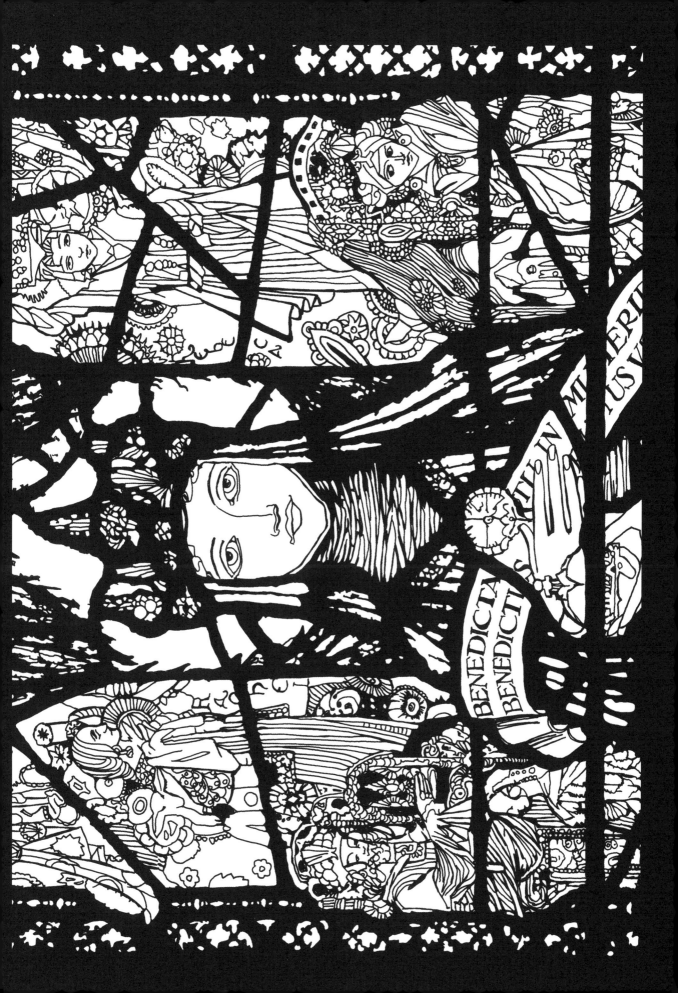

St Elizabeth of Hungary. Detail from
*Madonna and Child with St Elizabeth of
Hungary and St Barbara.* St Mary's Church of
England church, Sturminster Newton. ▸

Based on a photograph by Michael Cullen, originally published
in *Strangest Genius: The Stained Glass of Harry Clarke*, by Lucy
Costigan and Michael Cullen, The History Press, 2010.

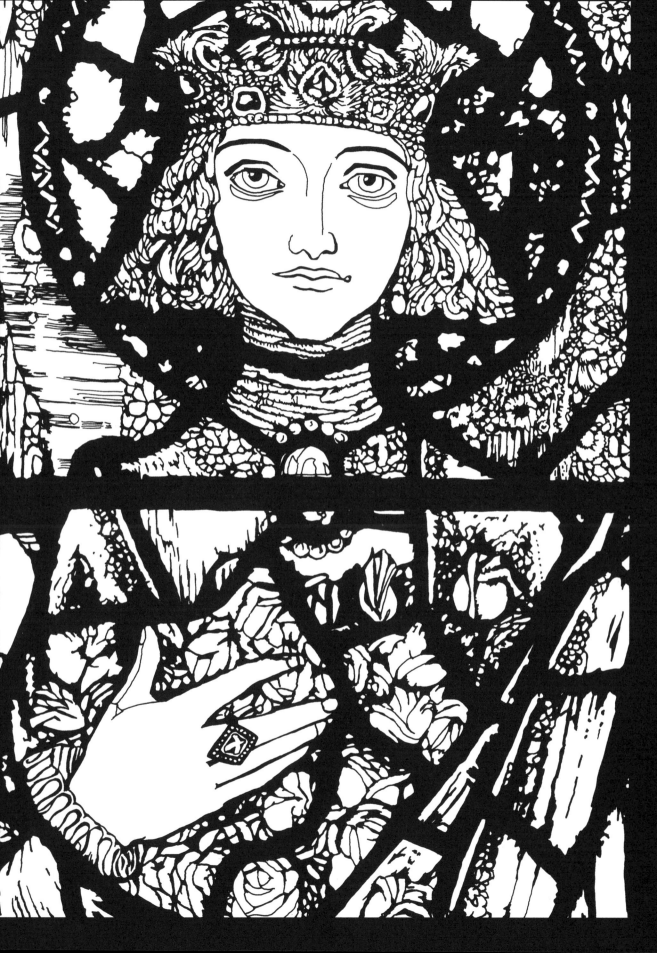

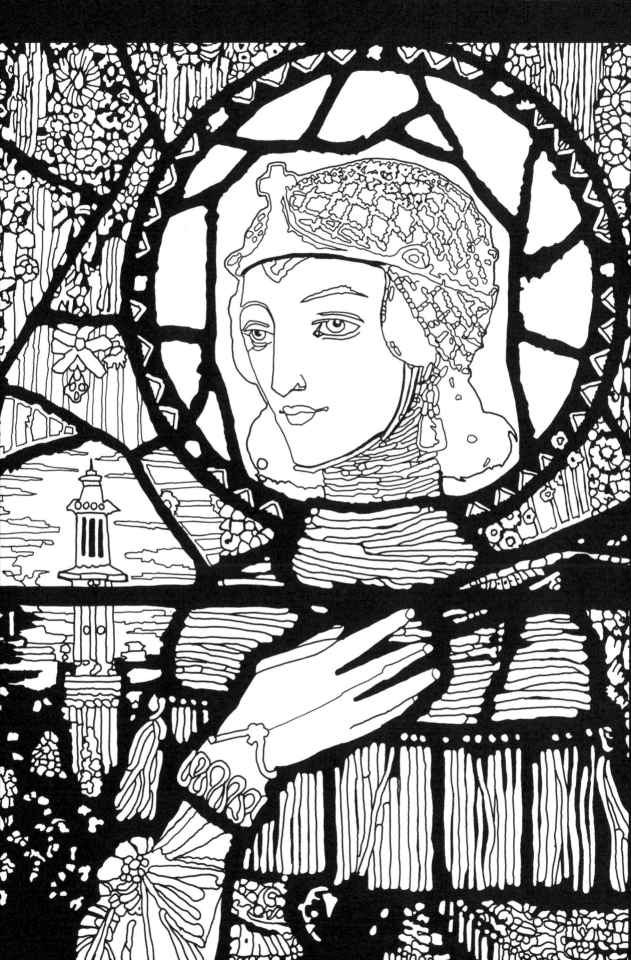

Panel 4 of the *Geneva Window*, depicting lines from *The Demi-Gods* by James Stephens and *Juno and the Paycock* by Sean O'Casey. ▸

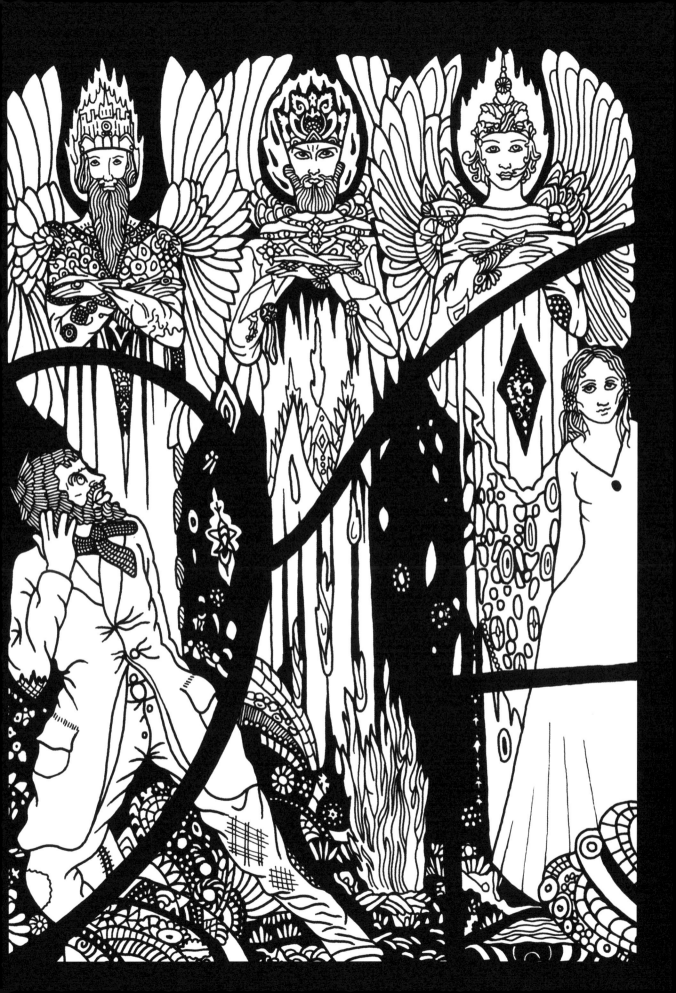

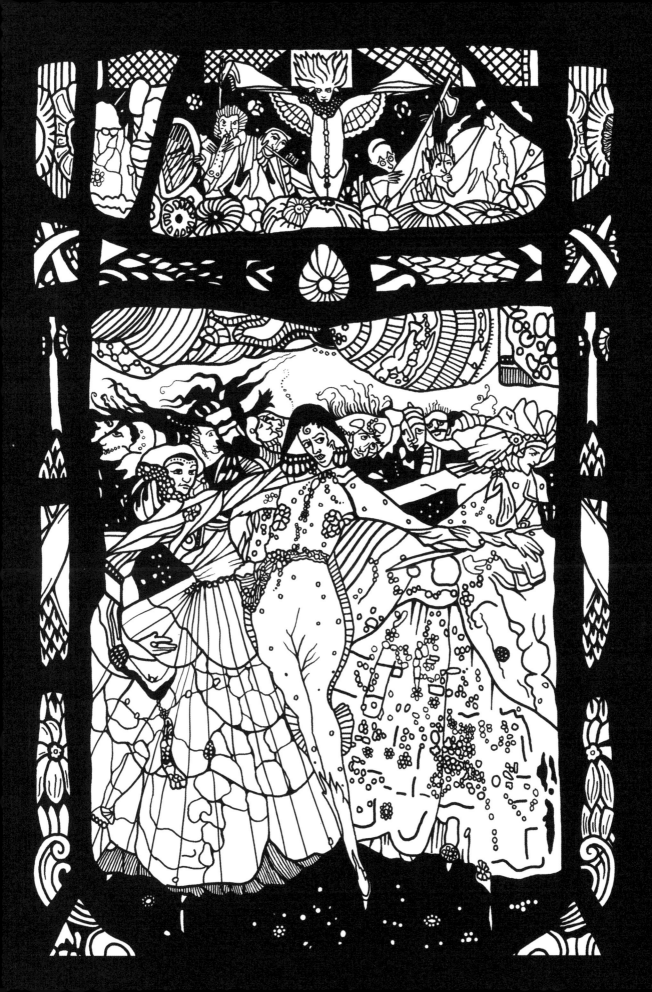

The Lady of the Decoration, from a calendar
designed and painted for the Glasgow
paint manufacturer John Duthie, 1914. ▸

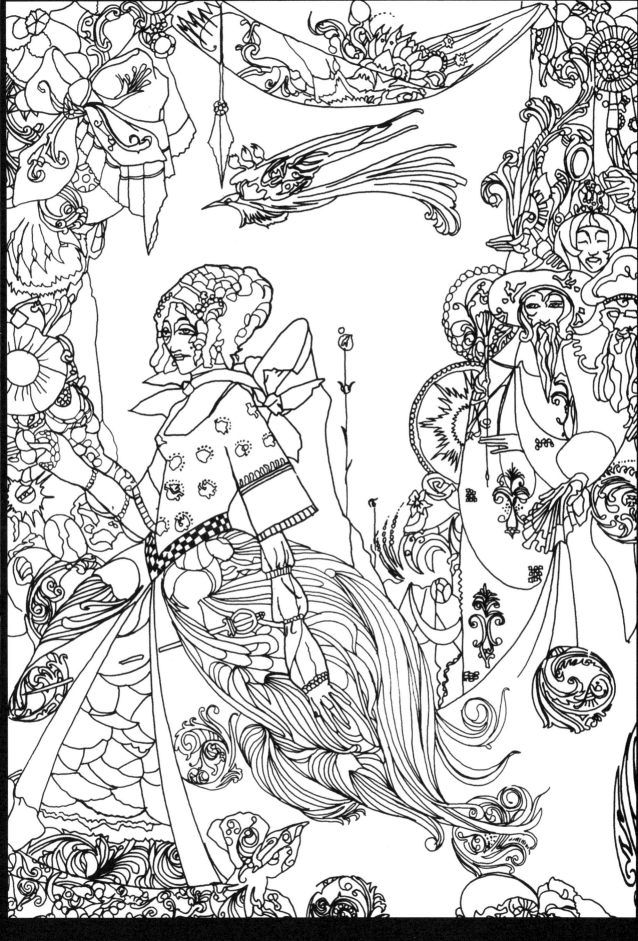

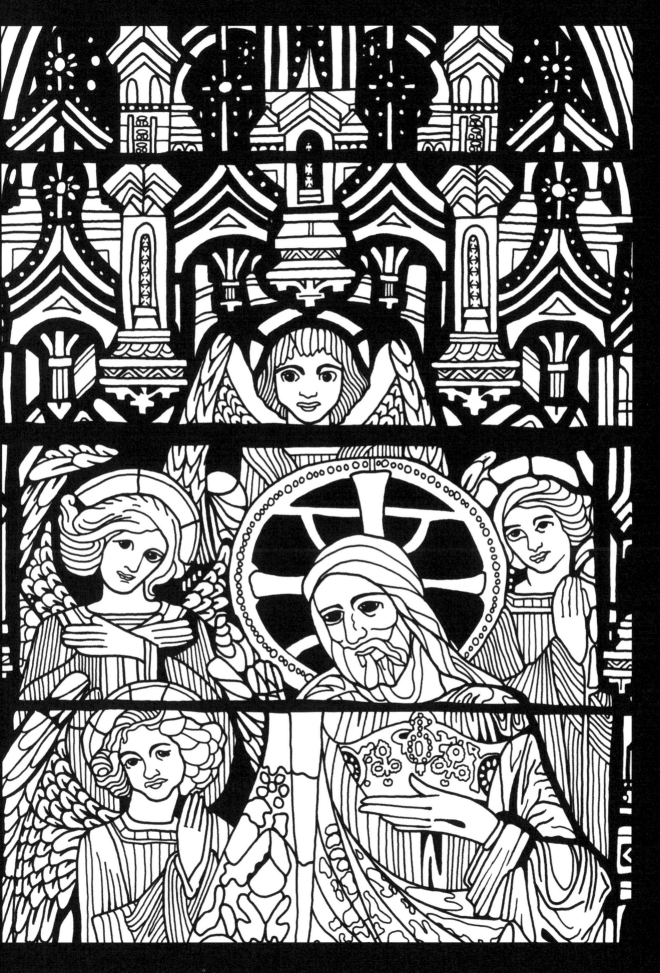

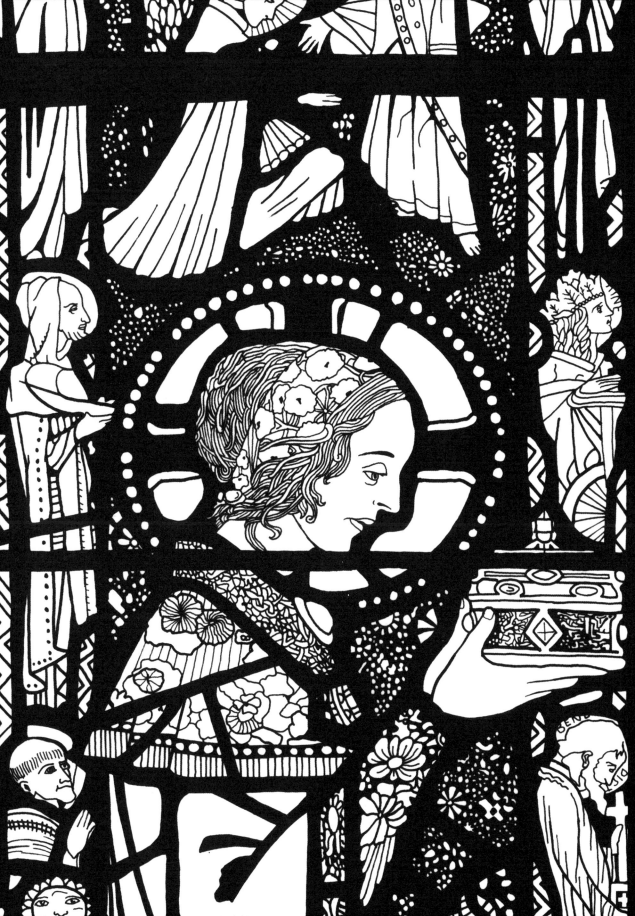

Cover of the catalogue for the fifth exhibition
of the Arts and Crafts Society of Ireland, 1917. ▶

Based on a print by George Roberts from a pen-and-ink design.

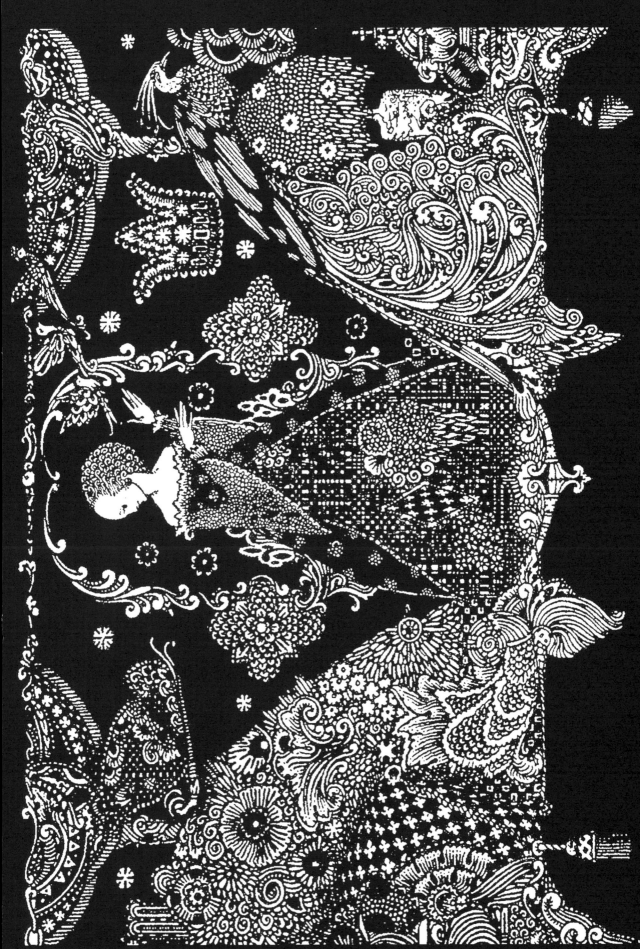

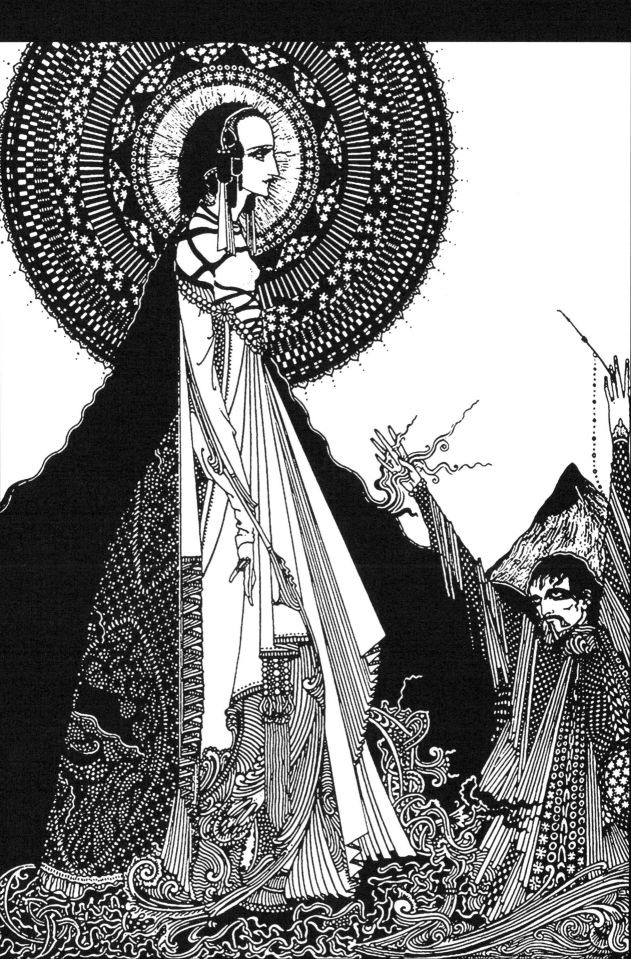

'Etain, Helen, Maeve, and Fand/Golden
Deirdre's tender hand', illustration to
J.M. Synge's poem, *Queens*, 1917. ▸

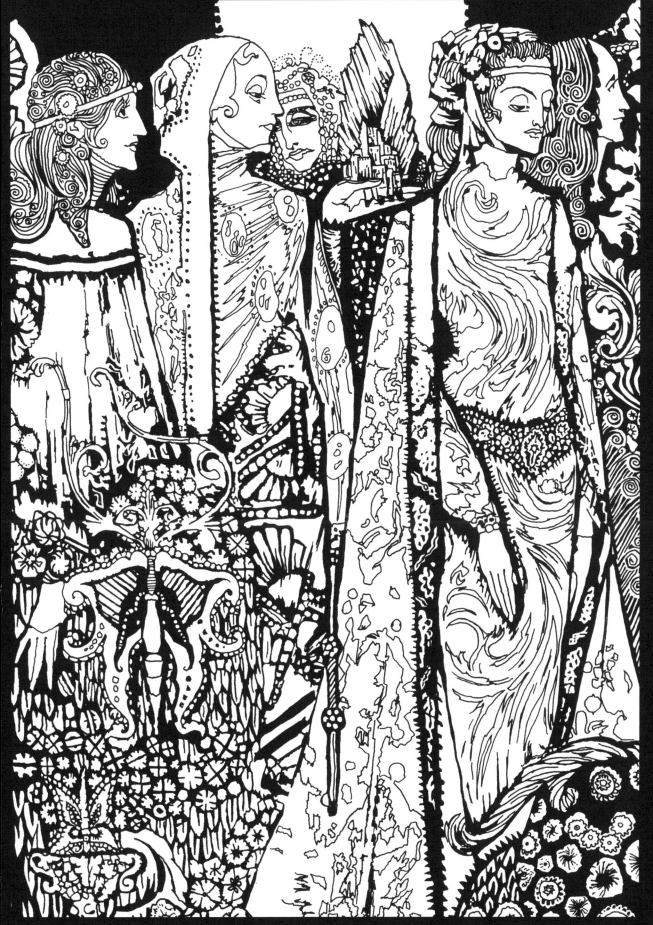

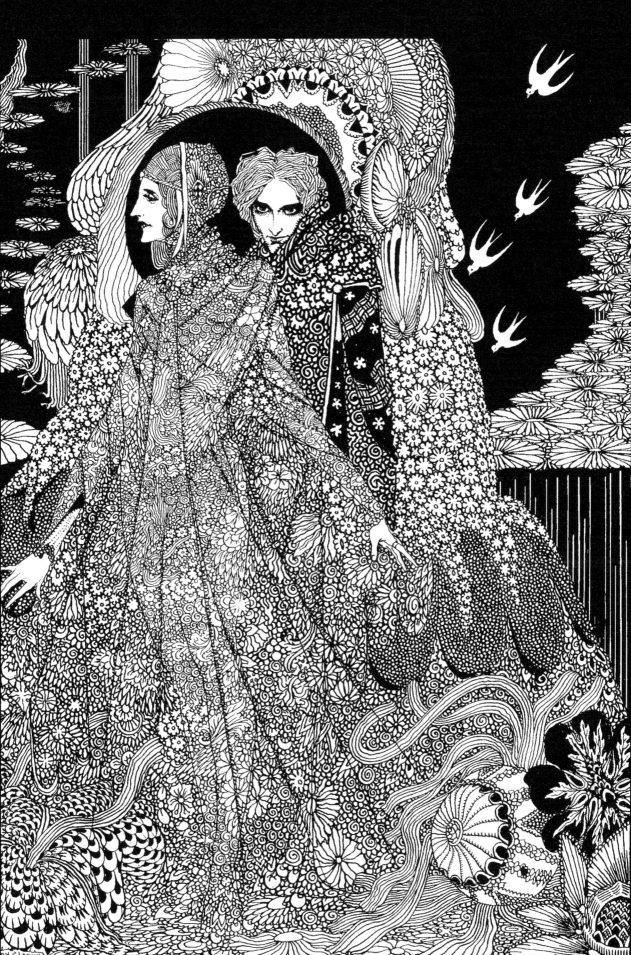

Detail of St Hubert, patron saint of huntsmen,
from the La Touche single-light memorial stained
glass window, St Patrick's church, Harristown,
Carnalway, near Kilcullen, County Kildare, 1921. ▸

Based on a photograph by Michael Cullen, originally published
in *Strangest Genius: The Stained Glass of Harry Clarke*, by Lucy
Costigan and Michael Cullen, The History Press, 2010.

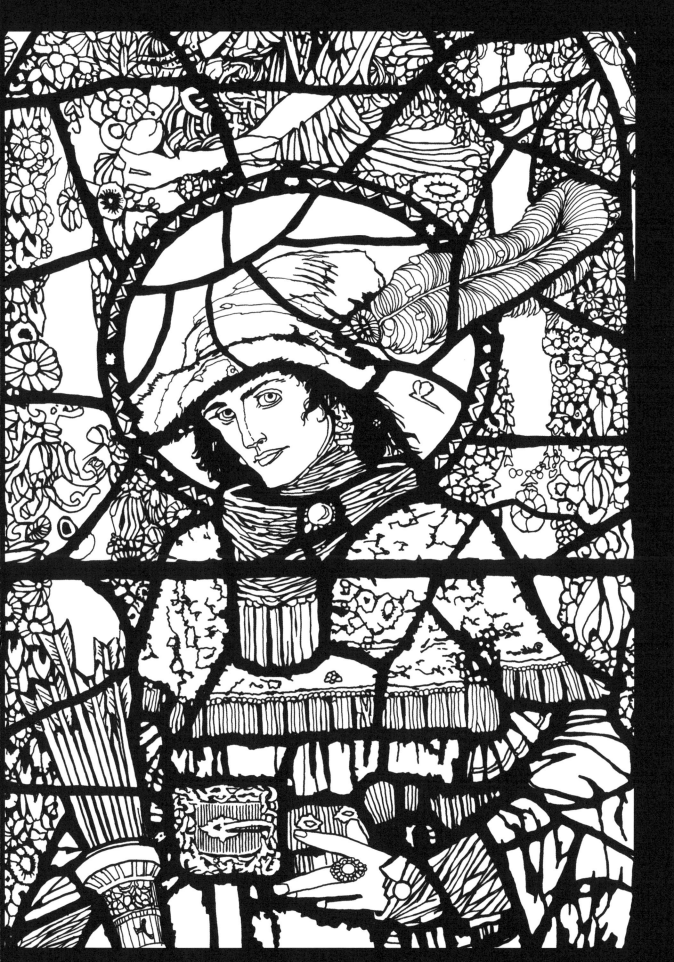

The Silver Apples of the Moon, the Golden Apples of the Sun, illustration from W.B. Yeats' poem, 'The Song of Wandering Aengus', 1913. ▸

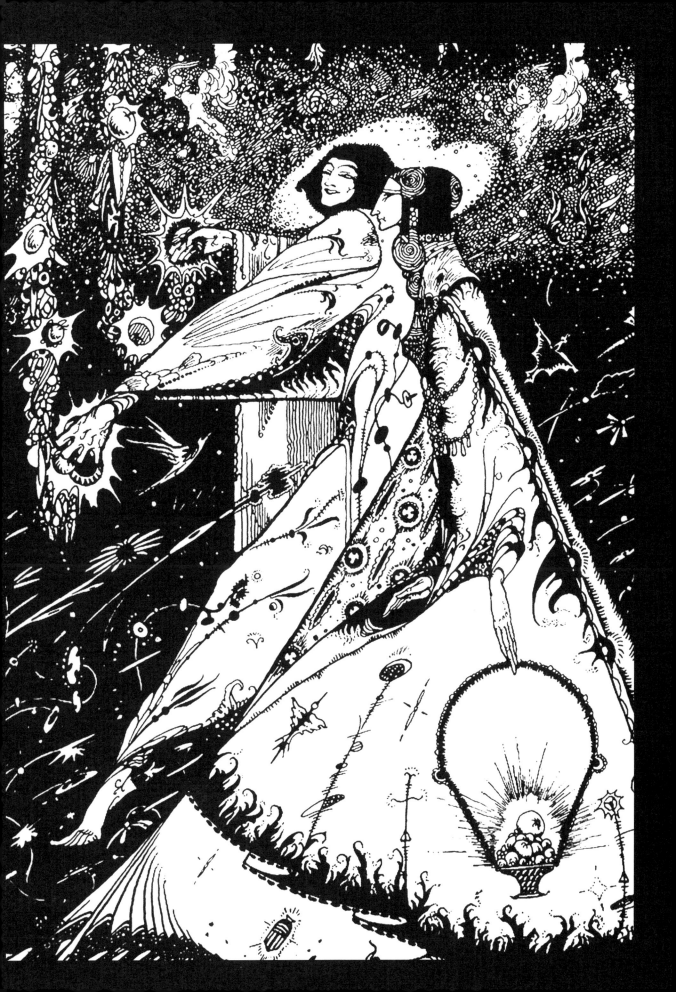

Detail of Adam and Eve and the Tree of Life
from the predella panel of *The Coronation of
the Blessed Virgin in Glory*, the Lady Chapel,
St Joseph's church, Terenure, Dublin, 1923. ▸

Based on a photograph by Michael Cullen, originally published
in *Strangest Genius: The Stained Glass of Harry Clarke*, by Lucy
Costigan and Michael Cullen, The History Press, 2010.

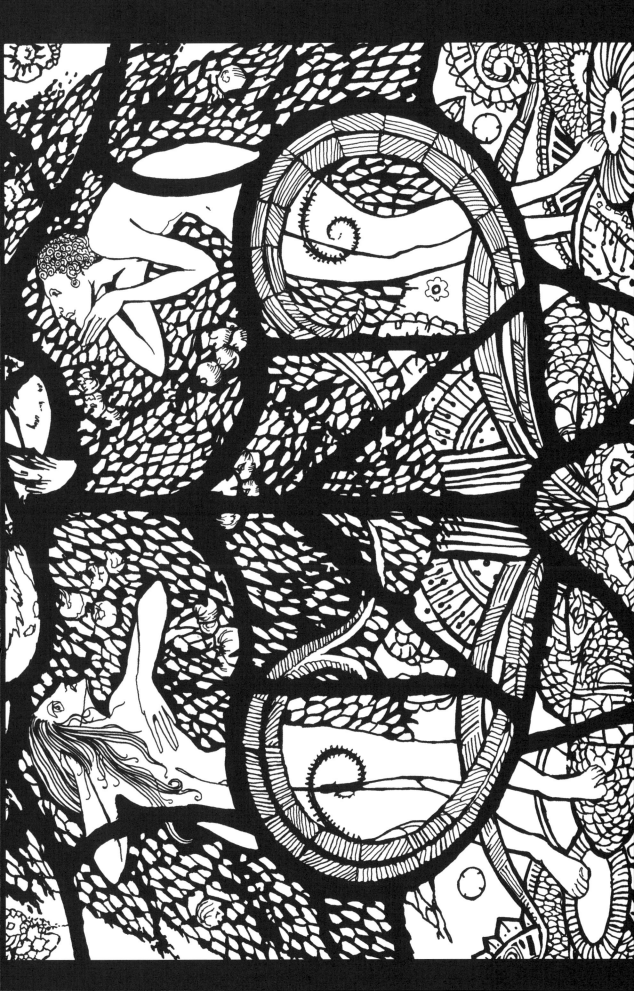

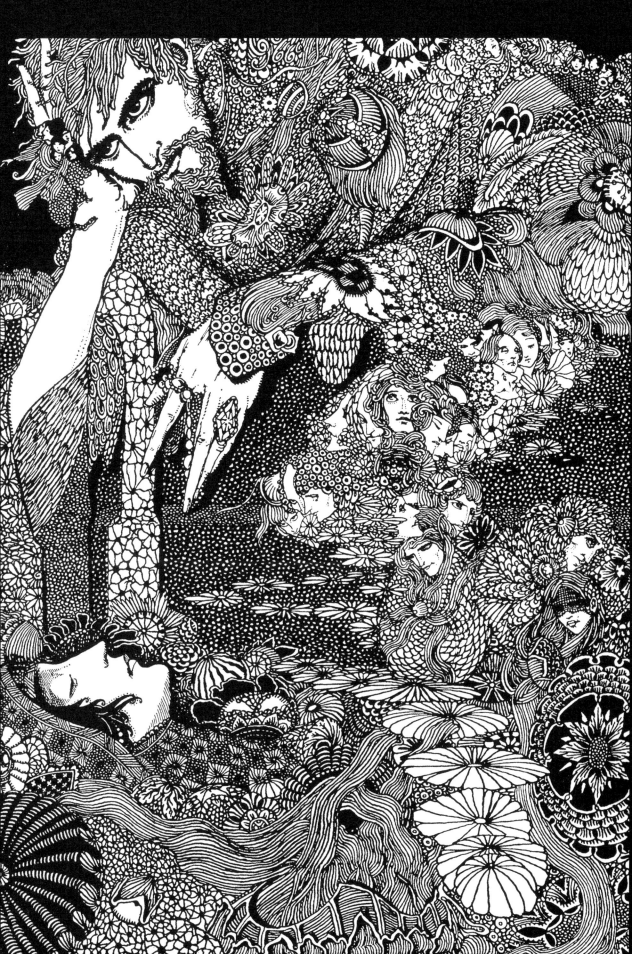

The Virgin and Child with St Cecilia and
Richard Coeur de Lion, detail of St Cecilia.
St Mary's church, Nantwich. ▸

Based on a photograph by Michael Cullen, originally published
in *Strangest Genius: The Stained Glass of Harry Clarke*, by Lucy
Costigan and Michael Cullen, The History Press, 2010.

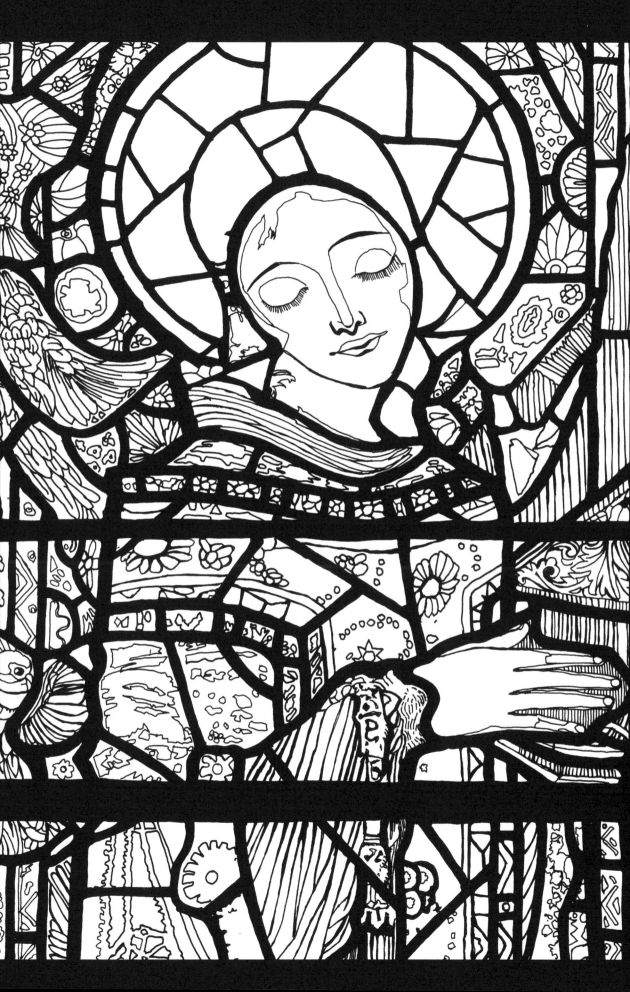

Eve of St Agnes, Section 5, panel 11. ▸

Based on photograph from the collection at
Dublin City Gallery, The Hugh Lane.

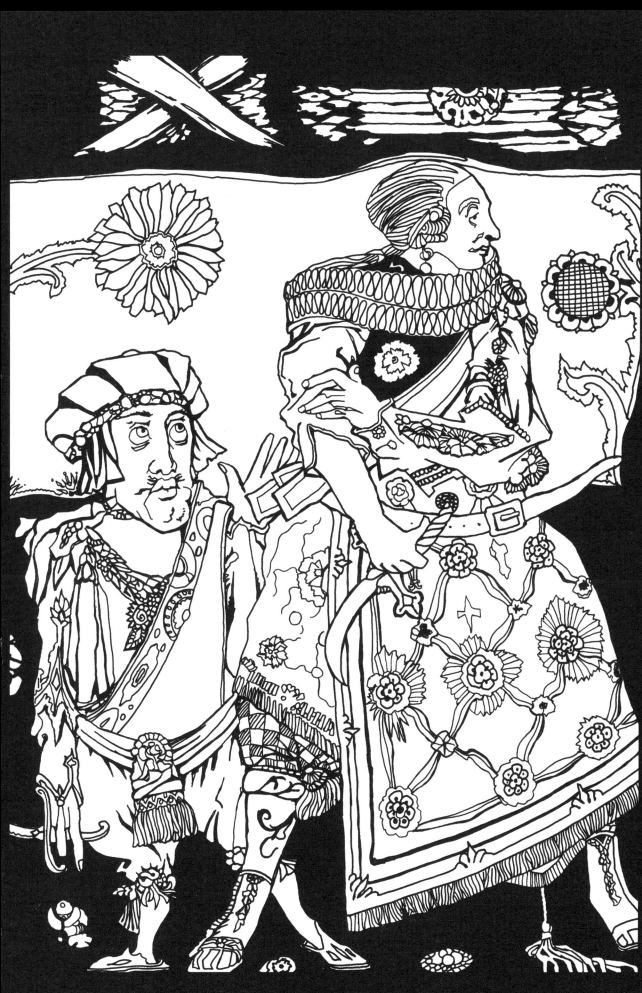

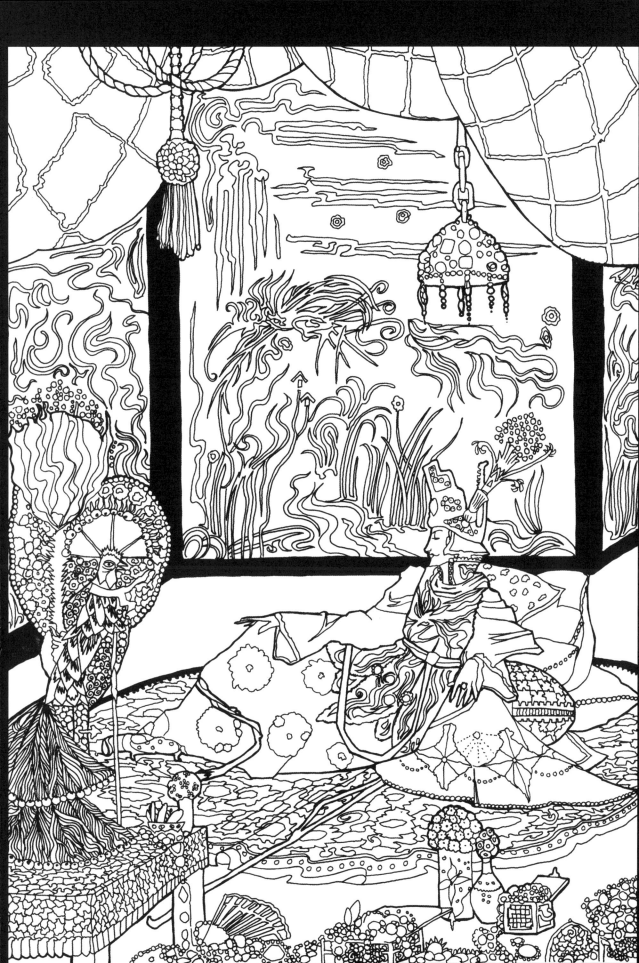

St Brigid, *The Crucifixion and the Adoration of the Cross by Irish Saints*, St Joseph's church, Terenure, Dublin 1920. ▸

Based on a photograph by Michael Cullen, originally published in *Strangest Genius: The Stained Glass of Harry Clarke*, by Lucy Costigan and Michael Cullen, The History Press, 2010.

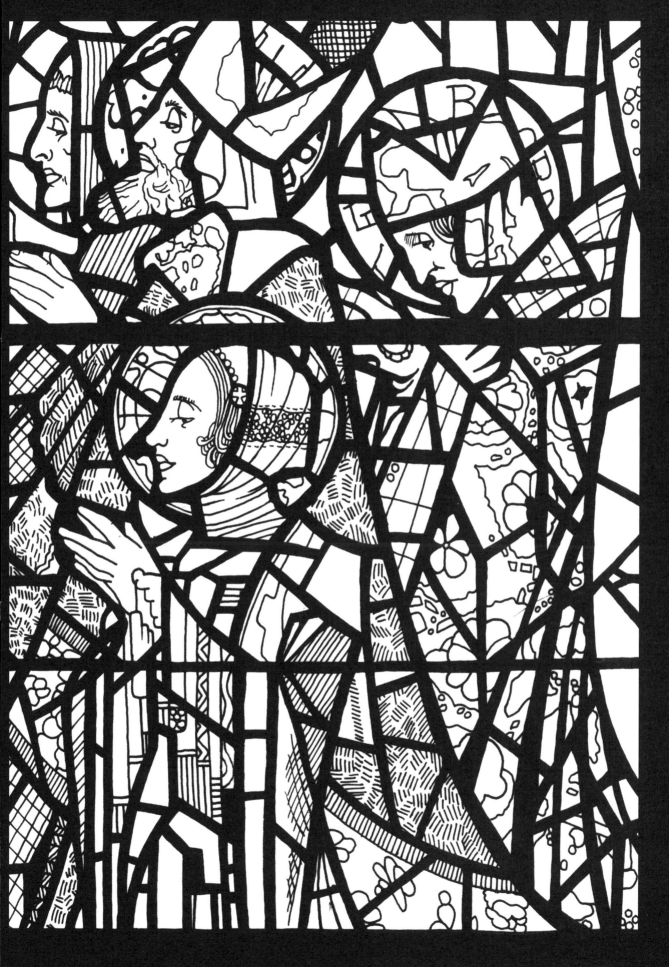

Geneva Window: Panel 3, depicting scenes from *The Playboy of the Western World* by John Millington Synge and 'The Others' by Seumas O'Sullivan. ▸

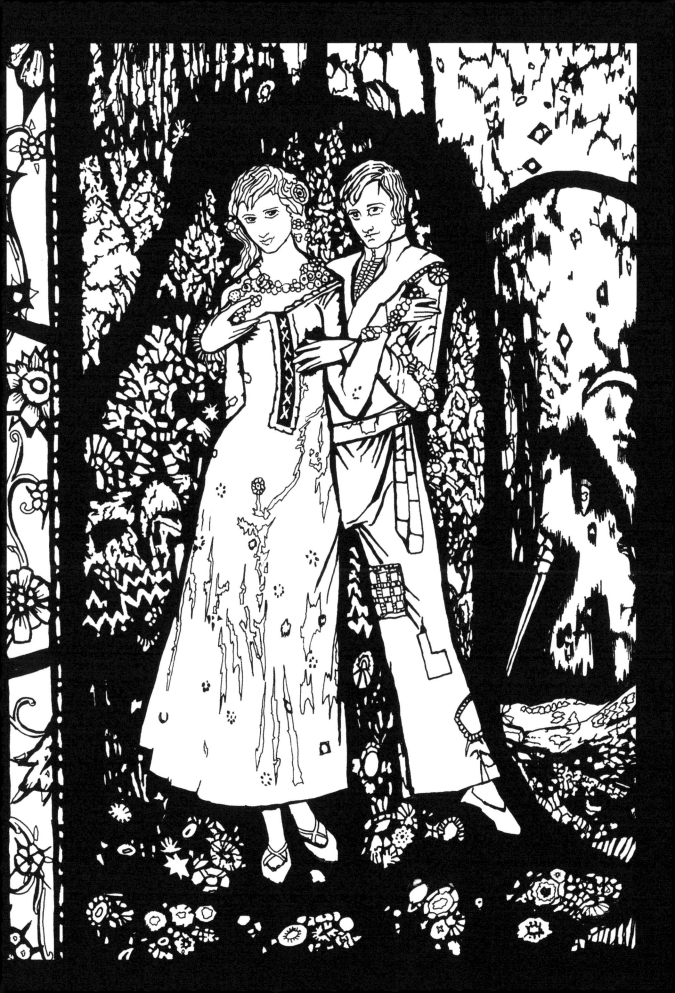